Cursive Hand Writing Workbook

每天8句正能量短語

靜心、美字
還能練出好英文

暢銷經典版

NEXUS Content Development Team 著

本書特色

- 用自己特有的筆跡，寫出帥氣的句子。

- 應用在卡片、信件或插畫等，增添豐富度。

- 集中注意力書寫，還能紓發壓力。

- 若想要享受獨自一人的時光，請使用本書。

- 透過書寫經典或著名的文句，也有助於提升英語實力。

- 掃描 QR Code 就可以邊看影片邊練字。

寫字的方法

- 用拇指和食指輕輕握住筆，並用中指支撐。

- 握筆時不要太靠前，也不要將筆立直書寫。

- 手和手腕放鬆，不要施太多力。

- 慢慢地按照字體模樣描繪。

- 不知道怎麼寫的時候，可以參考影片。

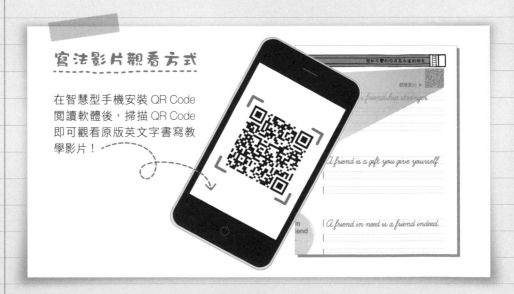

寫法影片觀看方式

在智慧型手機安裝 QR Code
閱讀軟體後，掃描 QR Code
即可觀看原版英文字書寫教
學影片！

Contents
目 錄

Writing Warming Up

 ## Week 1

 ## Week 2

 # Week 3

 # Week 4

每 天 8 句 正 能 量 短 語 ， 靜 心 、 美 字 ， 還 能 練 出 好 英 文 ！

Writing Warming Up

Capital Letters

大寫字母草寫

A

B

C

D

E

F

G

H

I

J

K

L

M

N

O

P

Q

R

S

T

U

V

W

X

Y

Z

Small Letters

小 寫 字 母 草 寫

a

b

c

d

e

f

g

h

i

j

k

l

m

n

o

p

q

r

s

t

u

v

w

x

y

z

Writing Alphabet

A a

A A A
a a a

寫寫看 ag 和 ar

ag ag ag
ar ar ar

B b

B B B
b b b

寫寫看 be 和 by

be be be
by by by

C c

C C C
c c c

寫寫看 ca 和 ch

ca ca ca
ch ch ch

D d

D D D
d d d

寫寫看 de 和 do

de de de
do do do

E e

E E E
e e e

寫寫看 ed 和 ev

ed ed ed
ev ev ev

觀看影片 ▶

寫寫看 fa 和 fr

寫寫看 ga 和 gr

寫寫看 ho 和 hy

寫寫看 il 和 in

寫寫看 je 和 jo

Writing Alphabet

K K K
k k k

寫寫看 ke 和 ky

ke ke ke
ky ky ky

L L L
l l l

寫寫看 la 和 lu

la la la
lu lu lu

M M M
m m m

寫寫看 mo 和 mu

mo mo mo
mu mu mu

N N N
n n n

寫寫看 ne 和 ny

ne ne ne
ny ny ny

O O O
o o o

寫寫看 on 和 oo

on on on
oo oo oo

P p

ppp

ppp

寫寫看 pa 和 pr

pa pa pa

pr pr pr

Q q

222

qqq

寫寫看 qu 和 qi

qu qu qu

qi qi qi

R r

RRR

rrr

寫寫看 rr 和 ry

rr rr rr

ry ry ry

S s

SSS

111

寫寫看 se 和 so

se se se

so so so

T t

TTT

ttt

寫寫看 th 和 to

th th th

to to to

Writing Alphabet

U u
U U U
u u u

寫寫看 un 和 us

un un un
us us us

V v
V V V
v v v

寫寫看 vi 和 vy

vi vi vi
vy vy vy

W w
W W W
w w w

寫寫看 wa 和 wh

wa wa wa
wh wh wh

X x
X X X
x x x

寫寫看 xe 和 xy

xe xe xe
xy xy xy

Y y
Y Y Y
y y y

寫寫看 ye 和 yo

ye ye ye
yo yo yo

Zz
Z z

寫寫看 ze 和 zo

z z z

ze ze ze

z z z

zo zo zo

練習大寫一筆到底

ABCDEFGHIJKLMNOPQRSTUVWXYZ

練習小寫一筆到底

abcdefghijklmnopqrstuvwxyz

15

每天8句正能量短語，靜心、美字，還能練出好英文！

Week 1

經常寫的句子 *Daily 1*

經常寫的句子 *Daily 2*

愛 *Love*

羅曼史 *Romance*

家庭 *Family*

友情 *Friendship*

美麗 *Beauty*

夢想 *Dream*

減肥 *Diet*

紀念日 *Anniversary*

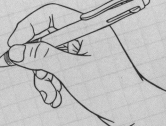

Daily

Dear,

親愛的 ~
（寫信或 email 的開頭）

Dear,

See you soon!

一會兒見！

See you soon!

Sincerely yours,

致我最真摯的朋友
（寫信或 email 的結尾）

Sincerely yours,

What a surprise!

真是個驚喜！

What a surprise!

觀看影片 ▶

Long time no see!

好久不見！

Long time no see!

How are you today?

你今天好嗎？

How are you today?

Thank you very much!

非常謝謝你！

Thank you very much!

I hope everything is okay.

希望一切順利。

I hope everything is okay.

Daily

Me too.

我也是。

Me too.

It's great!

真棒！

It's great!

Good luck.

祝你好運。

Good luck.

take a note

做個筆記。

take a note

觀看影片 ▶

Are you sure?

真的嗎？

| Are you sure?

Congratulations!

恭喜！

| Congratulations!

That's a great idea.

好主意。

| That's a great idea.

Sorry. It was all my fault.

抱歉，都是我的錯。

| Sorry. It was all my fault.

Lover

I love you.

我愛你。

I love you.

LIVE, LAUGH, LOVE

活著、笑著、愛著。

LIVE, LAUGH, LOVE

All you need is love.

你只需要愛。

- 披頭四 -

All you need is love.

Don't forget to love yourself.

別忘了要愛自己。

Don't forget to love yourself.

觀看影片 ▶

If you wished to be loved, love.

想要被愛，就先去愛。

If you wished to be loved, love.

Where there is love, there is life.

有愛的地方就有生命。
- 甘地 -

Where there is love, there is life.

Who, being loved, is poor?

被愛的人，有誰是不幸的呢？
- 奧斯卡 王爾德 -

Who, being loved, is poor?

Bitterness imprisons life; love releases it.

痛苦禁錮生活，
愛使人解脫。

Bitterness imprisons life; love releases it.

Romance

Romance is everything.

羅曼史是所有的一切。

Romance is everything.

Beauty is the lover's gift.

美麗是情人的禮物。

- 作家 威廉·康格里夫 -

Beauty is the lover's gift.

Romantic love is an addiction.

浪漫的愛讓人上癮。

Romantic love is an addiction.

My heart is like a singing bird.

我的心像一隻唱歌的鳥。

- 詩人 克里斯蒂娜·羅塞蒂 -

My heart is like a singing bird.

觀看影片 ▶

True love stories never have endings.

真愛的故事沒有完結篇。
-小說家 李察·巴哈-

True love stories never have endings.

You are the source of my joy.

你是我快樂的泉源。

You are the source of my joy.

You came and changed my world.

我的世界因著你的來到
而改變。

You came and changed my world.

I don't need paradise because I found you.

因為有了你，
我不需要天堂。

I don't need paradise because I found you.

25

Family

I love my family.

我愛我的家人。

I love my family.

Family is my everything.

家人是我的一切。

Family is my everything.

Home is where the heart is.

家是心之所在。

Home is where the heart is.

Family is a gift that lasts forever.

家人是永恆的禮物。

Family is a gift that lasts forever.

觀看影片 ▶

Family is life's greatest blessing.

家人是人生最好的祝福。

Family is life's greatest blessing.

A good home must be made not bought.

好的家不是買的，
而是組成的。

- 小說家 喬伊斯·梅納德 -

A good home must be made not bought.

There's no place like home.

沒有比家更好的地方。

There's no place like home.

A happy family is but an earlier heaven.

幸福的家庭宛如
早來的天堂。

- 伯納德·蕭 -

A happy family is but an earlier heaven.

Friendship

Best Friends Forever!

一輩子的好友！

Best Friends Forever!

Friends are born, not made.

朋友是先天的，而非後天的
（當朋友是無法勉強的）。

- 小說家 亨利·亞當斯 -

Friends are born, not made.

Good friends are hard to find.

知音難尋。

Good friends are hard to find.

Friends are the sunshine of life.

朋友是生命的陽光。

Friends are the sunshine of life.

觀看影片 ▶

Time makes friendship stronger.

時間使友誼更堅定。

Time makes friendship stronger.

A friend is a gift you give yourself.

朋友是你給自己的禮物。

A friend is a gift you give yourself.

A friend in need is a friend indeed.

患難見真情。

A friend in need is a friend indeed.

A friend is a second self.

朋友是另一個我。
（指心腹朋友）
- 亞里斯多德 -

A friend is a second self.

Beauty

You are beautiful.

你很漂亮。

You are beautiful.

Beauty is not in the face.

美，並不僅止於外貌。

Beauty is not in the face.

Things are beautiful if you love them.

只要有愛，凡事皆美。
- 法國 劇作家 尚·阿諾伊 -

Things are beautiful if you love them.

True beauty comes from within.

真正的美麗源自內在。

True beauty comes from within.

觀看影片 ▶

Beauty awakens the soul to act.

美喚醒靈魂而動。

- 義大利詩人
但丁・阿利吉耶里 -

Beauty awakens the soul to act.

Beauty is in the eye of the beholder.

情人眼裡出西施。

Beauty is in the eye of the beholder.

Beauty is a light in the heart.

美是心中的光芒。

Beauty is a light in the heart.

There is a kind of beauty in imperfection.

不完美亦是一種美。

There is a kind of beauty in imperfection.

Dream

I am a dreamer.

我是個夢想家。

I am a dreamer.

You can plant a dream.

夢想是可以栽種的。

- 安妮·坎貝爾 -

You can plant a dream.

Follow your dreams.

跟隨你的夢想。

Follow your dreams.

Dream it, Wish it, Do it

作夢、尋夢、圓夢！

Dream it, Wish it, Do it

觀看影片 ▶

Make your dreams happen.

實現你的夢想。

Make your dreams happen.

Dream as if you'll live forever.

彷彿你將永遠
活著地做夢吧！

Dream as if you'll live forever.

Sometimes your dreams come true.

有時你的夢想會成真。

- 拳擊手
法蘭克·布魯諾 -

Sometimes your dreams come true.

Nothing happens unless first we dream.

除非有夢想，
否則什麼事也不會發生。

Nothing happens unless first we dream.

Diet

Stay Healthy

保持健康。

Stay Healthy

Let's lose weight!

一起減肥吧！

Let's lose weight!

You earn your body.

你的身體是你自己贏得的。
（健康的身體是要付出代價的！）

You earn your body.

The first wealth is health.

健康是最好的財富。

- 詩人 拉爾夫·沃爾多·愛默生 -

The first wealth is health.

觀看影片 ▶

Happiness lies first of all in health.

幸福的首要就是健康。

Happiness lies first of all in health.

A feeble body weakens the mind.

虛弱的身體會削弱了心靈。
-尚·雅克·盧梭-

A feeble body weakens the mind.

change your mind & change your body

改變想法，改變身體。

change your mind & change your body

Your body is a reflection of your lifestyle.

身體是生活型態的縮影。

Your body is a reflection of your lifestyle.

Anniversary

Wishing you a Happy New Year!

祝你新年快樂！

Wishing you a Happy New Year!

Happy Valentine's Day!

情人節快樂！

Happy Valentine's Day!

We wish you a merry Christmas!

祝你聖誕快樂！

We wish you a merry Christmas!

We wish you a very Happy holidays.

祝你假期愉快！

We wish you a very Happy holidays.

觀看影片 ▶

May you have a spectacular New Year.

祝你有個很棒的新年。

May you have a spectacular New Year.

Merry christmas to your family!

祝你們全家聖誕快樂！

Merry christmas to your family!

Warmest greetings and best wishes.

予你最窩心的問候，
並祝你心想事成。

Warmest greetings and best wishes.

Happy Birthday to you!

祝你生日快樂！

Happy Birthday to you!

每天8句正能量短語，靜心、美字，還能練出好英文！

Week 2

讀書 *Study*

工作 *Work*

商務 *Business*

成功 *Success*

失敗 *Failure*

態度 *Attitude*

領導力 *Leadership*

知識 *Knowledge*

過失 *Mistake*

機會 *Chance*

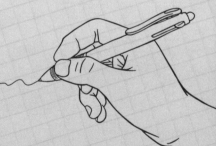

Study

Do your best.
盡你所能。

Do your best.

Education is the best provision for old age.
教育是防老的最佳糧食。
- 亞里斯多德 -

Education is the best provision for old age.

Wake up, seize the day.
起床並把握時光！

Wake up, seize the day.

Study while others are sleeping.
趁別人在睡覺的時候，讀書吧！

Study while others are sleeping.

觀看影片 ▶

Study hard now and enjoy later.

現在努力念書，
以後才能享受。

Study hard now and enjoy later.

Nothing worth having comes easy.

值得擁有的東西永遠
來之不易。

Nothing worth having comes easy.

KEEP CALM AND DESTROY EXAMS.

保持冷靜，擊退考試。

KEEP CALM AND DESTROY EXAMS.

To acquire knowledge, one must study.

想要得到知識就必須學習。
- 專欄作家
瑪麗蓮‧莎凡特 -

To acquire knowledge, one must study.

Love what you do.

愛你所做的事。

Love what you do.

Work hard, dream big.

努力工作，大膽作夢。

Work hard, dream big.

Hard work beats talent.

努力工作，戰勝天賦。

Hard work beats talent.

There is no substitute for hard work.

努力沒有替代品。

- 愛迪生 -

There is no substitute for hard work.

觀看影片 ▶

Without labor nothing prospers.

沒有勞動就沒有收穫。

- 索福克勒斯 -

Without labor nothing prospers.

Hard work always pays off.

努力總會有回報。

Hard work always pays off.

A job isn't just a job. It's who you are.

工作不只是工作，
它反映出你是
怎樣的一個人。

A job isn't just a job. It's who you are.

Don't complain. Just work harder.

別抱怨，更努力吧！

Don't complain. Just work harder.

Business

Exchange ideas frequently.

經常交流想法吧！
- 事業家
詹姆士·凱許·潘尼 -

Exchange ideas frequently.

Test fast, fail fast, adjust fast.

趕快測試，趕快失敗，
趕快調整。
- 經營學者 湯姆·彼得斯 -

Test fast, fail fast, adjust fast.

Details create the big picture.

細節造就全貌。

Details create the big picture.

So little done, so much to do.

已做的少，要做的多。
- 政治家
塞西爾·羅德斯 -

So little done, so much to do.

觀看影片 ▶

If it doesn't sell, it isn't creative.

賣不好就代表
不夠創新。

If it doesn't sell, it isn't creative.

Punctuality is the soul of business.

守時是在商之魂。
- 湯瑪士·哈利伯頓 -

Punctuality is the soul of business.

Word of mouth is the best medium of all.

口碑是最棒的宣傳工具。
- 創作者
威廉·伯恩巴克 -

Word of mouth is the best medium of all.

We're all working together.

我們一起工作。

We're all working together.

Success

Be brave and take risks.

勇於冒險。

Be brave and take risks.

Success comes with hard work.

成功來自努力。

Success comes with hard work.

Success is dependent on effort.

成功取決於是否努力。

Success is dependent on effort.

Action is the key to all success.

成功的所有鑰匙是行動。

- 畢卡索 -

Action is the key to all success.

There is no success without hardship.

不經一番寒徹骨，
哪得梅花撲鼻香！
（沒有艱苦就沒有成功。）
- 索福克勒斯 -

There is no success without hardship.

There is no elevator to success.

成功沒有捷徑。

There is no elevator to success.

You must believe that you can.

要相信自己做得到。

You must believe that you can.

Winning is the only thing.

贏是唯一。

Winning is the only thing.

Failure

Don't be afraid of failure.

不要害怕失敗。

Don't be afraid of failure.

Failing is not always failure.

失敗並不代表總是失敗。

Failing is not always failure.

Try and fail, but never fail to try.

寧願嘗試後失敗，
也不要從未嘗試過。

Try and fail, but never fail to try.

Every failure is a step to success.

每一次失敗皆是
邁向成功的一步。

- 威廉・惠威爾 -

Every failure is a step to success.

觀看影片 ▶

**Fall seven
times,
stand up eight.**

百折不撓！
（跌倒了七次，
卻站起來八次。）

Fall seven times, stand up eight.

**Sometimes
the best gain
is to lose.**

有時候吃虧就是佔便宜。
- 喬治·赫伯特 -

Sometimes the best gain is to lose.

**There is no
failure except
giving up.**

除了放棄，
沒有什麼是失敗的。

There is no failure except giving up.

**No man is
a failure who
is enjoying life.**

享受生活的人
就不會是失敗者。
- 威廉·費德 -

No man is a failure who is enjoying life.

49

Attitude

Respect differences.

尊重差異性。

Respect differences.

You get what you give.

得其所栽。
（你付出就會有收穫。）

You get what you give.

Brevity is the soul of wit.

言以簡為貴。
（簡潔是智慧的靈魂）
- 莎士比亞 -

Brevity is the soul of wit.

Honesty is the best policy.

誠實為上策。
- 班傑明·富蘭克林 -

Honesty is the best policy.

觀看影片 ▶

Everybody needs somebody.

每個人都會需要某個人。

Everybody needs somebody.

Don't be afraid to ask for help.

勿懼求援。

Don't be afraid to ask for help.

Attitude determines the altitude of life.

態度決定人生的高度。
- 愛德溫‧路易‧科爾 -

Attitude determines the altitude of life.

The only disability in life is a bad attitude.

人生唯一的殘疾
就是不好的態度。

The only disability in life is a bad attitude.

Leadership

Example is leadership.

模範就是領導力。
- 阿爾伯特·史懷哲 -

Example is leadership.

Leadership is influence.

領導力就是影響力。
- 約翰·馬克斯韋爾 -

Leadership is influence.

A leader is a dealer in hope.

領導者是販賣希望的商人。
- 拿破崙 -

A leader is a dealer in hope.

Don't find fault, find a remedy.

別找碴，找解方。
- 亨利·福特 -

Don't find fault, find a remedy.

觀看影片 ▶

What helps people, helps business.

有助於人的亦有助於企業。
- 萊奧·柏奈特 -

What helps people, helps business.

Today a reader, tomorrow a leader.

今日讀書的人，
就是明日的領導者。
- 瑪格麗特·富勒 -

Today a reader, tomorrow a leader.

Leadership is being a servant first.

領導力就是先成為
一個侍奉者。
（登高必自卑，
行遠必自邇）

Leadership is being a servant first.

Leadership doesn't depend on being right.

領導力並不是取決於
對或錯。

Leadership doesn't depend on being right.

Knowledge

Knowledge is power.

知識就是力量。

Knowledge is power.

Knowledge empowers you.

知識會賦與你力量。

Knowledge empowers you.

Always seek knowledge.

不斷求知。

Always seek knowledge.

The adventure of life is to learn.

人生的冒險就是學習。

The adventure of life is to learn.

觀看影片 ▶

Learning never exhaust the mind.

心靈永遠不會因學習
而精疲力竭。

- 李奧納多·達文西 -

Learning never exhaust the mind.

All of life is a constant education.

人生是永無止盡的教育。

All of life is a constant education.

Power is gained by sharing knowledge.

力量是透過
共享知識獲得的。

Power is gained by sharing knowledge.

A good decision is based on knowledge.

好的決策立基於知識。

- 柏拉圖 -

A good decision is based on knowledge.

Mistake

We all make mistakes.

我們都會犯錯。

We all make mistakes.

The biggest mistake is complacency.

自滿是最大的失誤。
- 企業家 邦妮 · 漢默 -

The biggest mistake is complacency.

Your best teacher is your last mistake.

上一次失誤是最好的老師。
- 人民運動家
拉爾夫 · 納德 -

Your best teacher is your last mistake.

Life is not life unless you make mistakes.

沒有失誤的人生
就不是人生。

Life is not life unless you make mistakes.

觀看影片 ▶

Making mistakes is a part of life.

犯錯不過是
人生中的一部分。

Making mistakes is a part of life.

We learn from failure, not from success.

我們透過失敗學習，
而非透過成功來學習。

We learn from failure, not from success.

Wise men learn by other men's mistakes.

聰明的人透過別人的
失敗學習。

Wise men learn by other men's mistakes.

Mistakes are proof that you are trying.

失誤是你正在努力的證據。

Mistakes are proof that you are trying.

57

Chance

Take a chance!

把握機會哦！
（亦有碰運氣之意）

Take a chance!

Everyday is a second chance.

每一天都是新的開始。

Everyday is a second chance.

If you never try, you'll never know.

如果不去試，
就永遠也不會知道。

If you never try, you'll never know.

Always do what you are afraid to do.

害怕的事更要去做。
- 詩人
拉爾夫·沃爾多·愛默生 -

Always do what you are afraid to do.

觀看影片 ▶

The only safe thing is to take a chance.

最安全的事就是抓住機會。
- 電影導演 麥克·尼可斯 -

The only safe thing is to take a chance.

Just keep taking chances.

就繼續碰碰運氣吧！

Just keep taking chances.

To success, one must take chances.

為了成功就該抓住機會。

To success, one must take chances.

If the sun comes up, I have a chance.

只要太陽升起，
我就有一個機會。

If the sun comes up, I have a chance.

每天8句正能量短語，靜心、美字，還能練出好英文！

Week 3

年齡 Age

人生 Life

經驗 Experience

智慧 Wisdom

改變 Change

未來 Future

時間 Time

旅行 Travel

電影 經典台詞 Movie

歌詞 Music

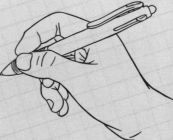

Age is no barrier.
年齡無礙。

Age is no barrier.

Youth has no age.
青春無限。
- 畢卡索 -

Youth has no age.

If youth knew; if age could.
年少怨無知，年老嘆無力。
- 佛洛伊德 -

If youth knew; if age could.

Age is no guarantee of maturity.
年紀並不保證成熟。

Age is no guarantee of maturity.

觀看影片 ▶

Live your life and forget your age!

忘記年齡，活出人生。

Live your life and forget your age!

Minds ripen at very different ages.

心智在不同的年齡層中成熟。
- 史提夫·汪達 -

Minds ripen at very different ages.

Age is a matter of feeling.

年齡 (不是歲數的問題)
是心境的問題。

Age is a matter of feeling.

Every age has its happiness and troubles.

每個年紀都各有其甘苦。
（每個人生時期都有其
快樂和煩惱。）
- 珍妮·卡爾芒 -

Every age has its happiness and troubles.

So it goes.

就這樣的逝去。

So it goes.

Life is short.

人生苦短。

Life is short.

Life is beautiful.

生命之美好。

Life is beautiful.

Life is the most wonderful fairy tale.

生命本身就是
最美妙的童話故事。
- 漢斯·安徒生 -

Life is the most wonderful fairy tale.

觀看影片 ▶

Live each day as if it's your last.

把每一天當作人生的最後一天過。

Live each day as if it's your last.

If you love life, don't waste time.

如果熱愛生命，就別浪費時間。

- 李小龍 -

If you love life, don't waste time.

Our life is what our thoughts make it.

我們的人生是由想法所創造的。

- 馬可·奧里略 -

Our life is what our thoughts make it.

Life is about creating yourself.

生命的價值在於創造自己。

Life is about creating yourself.

Experience

Experience is a great teacher.

經驗是良師。

Experience is a great teacher.

Every moment is an experience.

每一刻皆是體驗。
- 職業摔角選手
傑克·羅勃茲 -

Every moment is an experience.

Stay patient and trust your journey.

沉穩地相信你的旅程。

Stay patient and trust your journey.

Nothing can substitute experience.

沒有任何事物能夠取代經驗。
- 保羅·科爾賀 -

Nothing can substitute experience.

觀看影片 ▶

The reward of suffering is experience.

經驗是痛苦的報酬。

- 哈瑞·杜魯門 -

The reward of suffering is experience.

Experience is the teacher of all things.

經驗是所有事物的老師。

Experience is the teacher of all things.

We are a product of all our experiences.

我們是經驗的產物。

We are a product of all our experiences.

The source of knowledge is experience.

知識的泉源是經驗。

- 愛因斯坦 -

The source of knowledge is experience.

Wisdom

Wisdom begins in wonder.

智慧始於好奇心。
- 蘇格拉底 -

Wisdom begins in wonder.

Wisdom outweighs any wealth.

智慧超越任何財富。

Wisdom outweighs any wealth.

Turn your wounds into wisdom.

將你的傷口變成智慧。
- 歐普拉·溫芙蕾 -

Turn your wounds into wisdom.

Wisdom is knowing what to do next.

知道下一步該作什麼
是一種智慧。

Wisdom is knowing what to do next.

觀看影片 ▶

A wise man makes his own decisions.

聰明人會自己做決定。

A wise man makes his own decisions.

Wisdom is the right use of knowledge.

正確使用知識是一種智慧。

Wisdom is the right use of knowledge.

Knowledge speaks, but wisdom listens.

知識會說話，但智慧會傾聽。
- 吉米·亨德里克斯 -

Knowledge speaks, but wisdom listens.

Wisdom sails with wind and time.

智慧順著風、
隨著時間一起航行。
- 約翰·弗洛里奧 -

Wisdom sails with wind and time.

Change

Change the world!

改變世界吧！

Change the world!

Change is inevitable.

改變是不可避免的。

Change is inevitable.

Only I can change my life.

只有我能夠改變我的人生。

Only I can change my life.

Change brings opportunity.

改變帶來機會。

- 尼杜‧庫比恩 -

Change brings opportunity.

觀看影片 ▶

Change before you have to.

在不得不改變之前先改變。
- 約翰·法蘭西斯 -

Change before you have to.

Nothing endures but change.

變是唯一不變的。
- 赫拉克利特 -

Nothing endures but change.

Things do not change; we change.

變的不是世界，
變的是我們。

Things do not change; we change.

Ignorance is always afraid of change.

無知總是畏懼改變。
- 賈瓦哈拉爾·尼赫魯 -

Ignorance is always afraid of change.

Future

The future is now.

未來就是現在。

The future is now.

Your future is bright.

你的未來是光明的。

Your future is bright.

Only you can control your future.

只有你可以控制你的未來。

- 作家 蘇斯博士 -

Only you can control your future.

The past doesn't equal the future.

過去不等於未來。

The past doesn't equal the future.

觀看影片 ▶

Your past never defines your future.

你的過去絕不代表
你的未來。

Your past never defines your future.

The youth is the hope of our future.

年輕人是我們未來的希望。

- 菲律賓英雄 黎剎 -

The youth is the hope of our future.

The future starts today, not tomorrow.

未來不是從明天
而是從今天開始。

- 若望·保祿二世

The future starts today, not tomorrow.

The best way to predict future is create it.

預測未來的最佳方法
就是創造它。

The best way to predict future is create it.

73

Time

Time flies.

時光飛逝。

Time flies.

Time is money.

時間就是金錢。

Time is money.

Lost time is never found again.

失去的時間永遠不會再回來。

- 班傑明·富蘭克林 -

Lost time is never found again.

We must use time creatively.

我們要有創意地運用時間。

We must use time creatively.

觀看影片 ▶

Time is free, but it's priceless.

時間是免費的，
但卻是無價的。

Time is free, but it's priceless.

Time is flying never to return.

時間飛逝，永不復返。
- 維吉爾 -

Time is flying never to return.

There is no time to waste.

沒有可浪費的時間。

There is no time to waste.

You may delay, but time will not.

你可以拖延，但時間無法。

You may delay, but time will not.

Travel

See the world!

看看這個世界！

See the world!

Go on an adventure.

去冒險吧。

Go on an adventure.

I am a travel enthusiast.

我是個旅遊狂。

I am a travel enthusiast.

Wherever you go, go with all your heart.

既來之則安之。

- 孔子 -

Wherever you go, go with all your heart.

觀看影片 ▶

Travel teaches as much as books.

旅行像書一樣，
教會我們許多事。

- 塞內加爾歌手
尤蘇安多爾 -

Travel teaches as much as books.

Life is short and the world is wide.

人生短暫，但世界寬廣。

Life is short and the world is wide.

Travel far enough you meet yourself.

旅行得夠遠，
便會遇見自己。

Travel far enough you meet yourself.

The world is yours to explore.

世界任由你去探險。

The world is yours to explore.

Movie

The heart wants what it wants.

隨心所欲。
< 手札情緣 >

The heart wants what it wants.

You are the reason I am.

你是我存在的理由。
< 美麗境界 >

You are the reason I am.

Life is a box of chocolates.

人生像一盒巧克力。
< 阿甘正傳 >

Life is a box of chocolates.

May the Force be with you.

願原力與你同在。
< 星際大戰 >

May the Force be with you.

觀看影片 ▶

Manners makes man.

禮儀，成就不凡的人。
< 金牌特務 >

Manners makes man.

Experience never gets old.

經歷才是你完勝的履歷。
< 高年級實習生 >

Experience never gets old.

Anyone can be anything.

任何人都有無限可能。
< 動物方程式 >

Anyone can be anything.

Life isn't always what one like.

人生無法總是隨心所欲。
< 羅馬假期 >

Life isn't always what one like.

Music

You are not alone.

你並不孤單。
< You Are Not Alone，
麥可·傑克森 >

You are not alone.

Isn't she lovely?

她真可愛啊！
< Isn't She Lovely，
史蒂夫汪達 >

Isn't she lovely?

I was born to love you.

我是為了愛你而誕生的。
< I Was Born To Love You，
皇后合唱團 >

I was born to love you.

A hero lies in you.

你心裡住著一個英雄。
< Hero，
瑪麗亞·凱莉 >

A hero lies in you.

觀看影片 ▶

Wanna love you in slow motion.

想要慢慢地愛你。
< Slow Motion，
Karina Pasian>

Wanna love you in slow motion.

There will be an answer. Let it be.

順其自然吧！
答案自然會出現。
<Let It Be，披頭四 >

There will be an answer. Let it be.

You raise me up to more than I can be.

你鼓舞我，
讓我能爬得更高。
<You Raise Me Up，
西城男孩 >

You raise me up to more than I can be.

I don't know why I didn't come.

我不知道我為何不曾走向你。
< Don't Know Why，
諾拉·瓊絲 >

I don't know why I didn't come.

81

每天8句正能量短語，靜心、美字，還能練出好英文！

Week 4

正向 *Positiveness*

幸福 *Happiness*

笑容 *Laughter*

感謝 *Thanks*

幸運 *Fortune*

信任 *Faith*

靈感 *Inspiration*

慰藉 *Comfort*

希望 *Hope*

和平 *Peace*

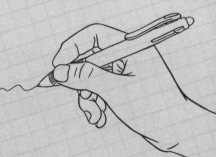

Positiveness

Nothing is impossible.

凡事都有可能。
（沒有什麼是不可能的。）

Nothing is impossible.

Think positive, be positive!

正向思考，要樂觀！

Think positive, be positive!

Positive thinking takes you far.

積極的想法會伴你遠行。

Positive thinking takes you far.

Be positive and laugh at everything.

正向思考並以笑容回應。
- 電影明星
亞莉珊卓·洛區 -

Be positive and laugh at everything.

觀看影片 ▶

A positive attitude gives you power.

正面的想法會給予你力量。

A positive attitude gives you power.

A positive attitude changes everything.

正面的態度能改變所有事。

A positive attitude changes everything.

I believe in being positive.

我相信正向的力量。
- 美式足球選手 喬・格林 -

I believe in being positive.

the power of positive thinking

正向思考的力量。

the power of positive thinking

Happiness

What makes you happy?

什麼讓你快樂？

What makes you happy?

Be happy for this moment.

享受當下的幸福。

Be happy for this moment.

Be happy & be bright & be you!

要快樂、要亮麗、要做自己！

Be happy & be bright & be you!

You can be happy where you are.

你在哪兒都要幸福。

- 約爾·歐斯汀 -

You can be happy where you are.

觀看影片 ▶

Happiness depends upon ourselves.

幸福是自己掌握的。
- 亞里斯多德 -

Happiness depends upon ourselves.

Today is the perfect day to be happy!

今天正是值得
幸福的好日子！

Today is the perfect day to be happy!

Happiness is itself a kind of gratitude.

幸福本身就是感激的心。

Happiness is itself a kind of gratitude.

The purpose of our lives is to be happy.

我們活著的目的
就是為了要幸福。
- 達賴喇嘛 -

The purpose of our lives is to be happy.

Laughter

Don't forget to smile!

別忘了要微笑！

Don't forget to smile!

Peace begins with a smile.

和平是從微笑開始。

- 德蕾莎修女 -

Peace begins with a smile.

You have a cute smile, smile more!

你的笑容很可愛，
要多笑喔！

You have a cute smile, smile more!

Laughing is the best form of therapy.

笑是最佳的治療方法。

Laughing is the best form of therapy.

觀看影片 ▶

A good laugh is sunshine in a house.

笑容是家裡的陽光。
- 小説家
威廉·薩克萊 -

A good laugh is sunshine in a house.

Humor is mankind's greatest blessing.

幽默是人類最偉大的祝福。

Humor is mankind's greatest blessing.

A day without laughter is a day wasted.

沒有笑容的一天
是浪費的一天。
- 查理·卓別林 -

A day without laughter is a day wasted.

Smile while you still have teeth.

趁牙齒還在的時候多笑吧！

Smile while you still have teeth.

Thanks

Be thankful!

心懷感恩！

Be thankful!

Gratitude is the sign of noble souls.

感激的心是
內心高貴的象徵。
- 伊索 -

Gratitude is the sign of noble souls.

Be grateful for small things.

對小事心懷感激。

Be grateful for small things.

Be thankful for the difficult times.

面對困境時，
要懂得感激。

Be thankful for the difficult times.

觀看影片 ▶

Start each day with a grateful heart.

用感恩的心開始每一天。

Start each day with a grateful heart.

You are blessed.

你是受到祝福的人。

You are blessed.

Appreciate everything that you have.

感謝你所擁有的一切。

Appreciate everything that you have.

Unseasonable kindness gets no thanks.

不懷好意是
無法獲得感謝的。
- 湯瑪斯·富勒 -

Unseasonable kindness gets no thanks.

Fortune

I feel very lucky.

我真幸運。

I feel very lucky.

making my own luck

機運是自己把握的！

making my own luck

Everything in life is luck.

生命中的一切都是機運。

- 唐納·川普 -

Everything in life is luck.

Luck is believing you're lucky.

好運就是相信
自己會很幸運。

- 田納西·威廉斯 -

Luck is believing you're lucky.

觀看影片 ▶

Care and diligence bring luck.

關懷和勤奮會帶來好運。

Care and diligence bring luck.

Luck is being ready for the chance.

好運是為了機會而準備的。

Luck is being ready for the chance.

The champion makes his own luck.

冠軍會創造自己的好運。

The champion makes his own luck.

The harder I work, the luckier I get.

越是勤奮努力，
就越是容易帶來好運。
- 電影製作人
塞繆爾·戈德溫 -

The harder I work, the luckier I get.

Faith

God only knows.

唯有神知道。

God only knows.

I believe in god.

我信仰上帝。

I believe in god.

God continues to work miracles.

上帝會繼續創造奇蹟。
- 電影明星 Willie Aames-

God continues to work miracles.

In him, there is no darkness at all.

在祂的世界裡沒有黑暗。

In him, there is no darkness at all.

觀看影片 ▶

Worry ends when faith in god begins.

信心的起頭，
就是憂慮的盡頭。

Worry ends when faith in god begins.

Have faith in god; god has faith in you.

信仰於神，祂便信仰於你。
- 愛德溫·路易·科爾 -

Have faith in god; god has faith in you.

We walk by faith, not by sight.

我們行事為人，是憑著信心，
不是憑著眼見。

We walk by faith, not by sight.

Where god guides, he provides.

當祂指引你，
祂便有預備。

Where god guides, he provides.

Either move or be moved.

消滅或被消滅。

- 詩人 艾茲拉·龐德 -

Either move or be moved.

When one must, one can.

一定要做到的時候，
我們都能做到。

When one must, one can.

Never, never, never give up!

絕不、絕不、絕不放棄！

Never, never, never give up!

Well done is better than well said.

做到比說到更好。

- 班傑明·富蘭克林 -

Well done is better than well said.

觀看影片 ▶

Never complain and never explain.

從不抱怨也永不解釋。
- 政治家
班傑明·迪斯雷利 -

Never complain and never explain.

If you can dream it, you can do it.

能夢到便能做到。
- 華特·迪士尼 -

If you can dream it, you can do it.

Step by step and the thing is done.

一步一步達成任務。

Step by step and the thing is done.

The more we do, the more we can do.

做越多便能做到更多。

The more we do, the more we can do.

Comfort

We are new every day.

每天都是全新的開始。

We are new every day.

Flowers grow out of dark moments.

花開在黑暗的片刻。

- 修女 柯莉塔・肯特 -

Flowers grow out of dark moments.

Everything is gonna be okay.

一切都會沒事的。

Everything is gonna be okay.

Glee! The great storm is over!

好極了，
暴風終於停止了。

Glee! The great storm is over!

觀看影片 ▶

The only cure for grief is action.

唯一能治療悲痛的就是行動。
-喬治·亨利·路易斯-

The only cure for grief is action.

The best is yet to come.

好戲在後頭。
（接下來會更精彩，值得期待）

The best is yet to come.

Sometimes you just need to breathe.

你偶爾也要喘口氣。
（意指放下、休息）

Sometimes you just need to breathe.

Forget the past and live the present hour.

忘卻過去，活在當下。

Forget the past and live the present hour.

Hope

Don't lose hope.

別失去希望。

Don't lose hope.

Great hopes make great men.

偉大的希望造就偉大的人。
- 湯瑪斯·富勒 -

Great hopes make great men.

No hope, no action.

沒希望就沒行動。

No hope, no action.

There is always hope.

希望一直都在。

There is always hope.

觀看影片 ▶

**Hope will
never be silent.**

希望永不沉默。
- 哈維‧米爾克 -

Hope will never be silent.

**Pain is real.
But so is hope.**

痛苦是真的，
但希望的力量也很真。

Pain is real. But so is hope.

**While
there is life,
there is hope.**

活著就有希望。

While there is life, there is hope.

**Hope is
the heartbeat
of the soul.**

希望是靈魂的心跳。

Hope is the heartbeat of the soul.

Inner Peace

內心的平靜。

Inner Peace

Let us have peace.

請賜予我們和平。

Let us have peace.

Love, Peace and Soul

愛，和平與靈魂。

Love, Peace and Soul

Peace is its own reward.

和平本身就是報答。

- 甘地 -

Peace is its own reward.

觀看影片 ▶

Peace comes from within.

寧靜來自於內心。
- 佛陀 -

Peace comes from within.

You can't find peace by avoiding life.

你無法藉由逃避生活
來找到寧靜。

You can't find peace by avoiding life.

We won't have peace by afterthought.

追悔得不到和平。
- 諾曼・考辛斯 -

We won't have peace by afterthought.

Nobody can bring you peace but yourself.

除了你自己，
沒人能帶給你平靜。

Nobody can bring you peace but yourself.

Twenty years from now you will be more
disappointed by the things that you didn't
do than by the ones you did do, so throw off
the bowlines, sail away from safe harbor,
catch the trade winds in your sails.
Explore, Dream, Discover.

— Mark Twain

20年後，會令你更失望的不是你做過的事，

而是你沒有做過的。所以，解開帆索，

駛離安全的港灣，乘（著信）風而行。

去探索、去夢想、去發現！

- 馬克‧吐溫 -

英文字書寫練習格線紙

Write

Write

每天 8 句正能量短語，靜心、美字，還能練出好英文(暢銷經典版)

作　　者：NEXUS Content Development Team
譯　　者：蘇琬清
企劃編輯：王建賀
文字編輯：王雅雯
設計裝幀：張寶莉
發 行 人：廖文良

發 行 所：碁峰資訊股份有限公司
地　　址：台北市南港區三重路 66 號 7 樓之 6
電　　話：(02)2788-2408
傳　　真：(02)8192-4433
網　　站：www.gotop.com.tw
書　　號：ALE001831
版　　次：2022 年 05 月二版
　　　　　2024 年 06 月二版三刷
建議售價：NT$199

國家圖書館出版品預行編目資料

每天 8 句正能量短語，靜心、美字，還能練出好英文 / NEXUS
Content Development Team 原著；蘇琬清譯. -- 二版. -- 臺北
市：碁峰資訊, 2022.05
　　面；　公分
　　ISBN 978-626-324-190-9(平裝)
　　1.CST：書法　2.CST：美術字　3.CST：英語
942.27　　　　　　　　　　　　　　　　111006831